D0456114

Digital Photography
1, 2, 3

TAKING & PRINTING
GREAT PICTURES

Book Design and Layout: Sandy Knight
Cover Design: Sandy Knight
Editorial Assistance: Haley Pritchard and Delores Gosnell

Library of Congress Cataloging-in-Publication Data
Sheppard, Rob.
 Digital photography 1, 2, 3 : taking and printing great pictures / Rob
Sheppard.-- 1st ed.
 p. cm.
 Includes index.
 ISBN 1-57990-676-1 (pbk.)
 1. Photography--Digital techniques--Handbooks, manuals, etc. 2. Digital
cameras--Handbooks, manuals, etc. I. Title. II. Title: Digital photography
one, two, three.
TR267.S5335 2005
775--dc22

 2004017948

10 9 8 7 6 5 4 3 2 1

First Edition

Published by Lark Books, A Division of
Sterling Publishing Co., Inc.
387 Park Avenue South, New York, N.Y. 10016

© 2005, Rob Sheppard
Photography © Rob Sheppard unless otherwise specified

Distributed in Canada by Sterling Publishing,
c/o Canadian Manda Group, 165 Dufferin Street
Toronto, Ontario, Canada M6K 3H6

Distributed in the U.K. by Guild of Master Craftsman Publications Ltd.,
Castle Place, 166 High Street, Lewes, East Sussex, England BN7 1XU
Tel: (+ 44) 1273 477374, Fax: (+ 44) 1273 478606,
Email: pubs@thegmcgroup.com; Web: www.gmcpublications.com

Distributed in Australia by Capricorn Link (Australia) Pty Ltd.,
P.O. Box 704, Windsor, NSW 2756 Australia

If you have questions or comments about this book, please contact:
Lark Books, 67 Broadway, Asheville, NC 28801
(828) 253-0467
www.larkbooks.com

Manufactured in China

ISBN 1-57990-676-1

Digital Photography
1, 2, 3

TAKING & PRINTING
GREAT PICTURES

BY ROB SHEPPARD

LARK BOOKS

Contents

Contents

1

The New Camera

Today's digital cameras look and act mostly like traditional cameras. Yet, there are a number of very important differences, including some that truly enhance our picture-taking experience. This chapter will offer you a quick overview of what you can expect from a digital camera.

Benefits of the Digital Camera

Today, digital cameras have transformed the marketplace—for good reason. Digital cameras offer a number of terrific advantages. It used to be that film had a slight quality edge in making larger prints, but this is no longer true. Even a simple 3-megapixel camera can easily match 35mm up to an 8 x 10-inch print. While there are still some advantages held by film cameras, these really pale in comparison to the great benefits that digital cameras offer most photographers.

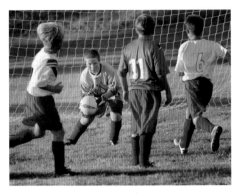

No Cost Pictures

Digital cameras are now affordable—comparably priced to film cameras of similar capabilities—and memory cards are inexpensive when you consider how many photos they can store. Plus, the cards can be used over and over again. This is a wonderful thing because you no longer have to worry about wasting film! If you think a photo might be interesting, take it. If you wonder what a certain setting on the camera will do, try it. You can't lose!

If a scene looks interesting, try it. With a digital camera, you have nothing to lose!

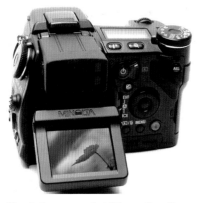

Check the camera's LCD monitor. If you don't like the picture, simply shoot it again.

Instant Feedback

I love this feature of a digital camera. The camera's LCD monitor is a tremendous resource. It allows you to check every aspect of an image, from composition to exposure, from white balance to the use of flash. You quickly see if you got the photo you expected or if you need to correct problems while you are still with the subject. Just think of what an advantage this is when taking pictures of your vacation or special family events!

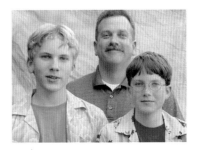

Quick Change
Light Sensitivity

With a digital camera, you can instantly change the light sensitivity to respond to different conditions by adjusting the ISO setting. With a push of a button or a new selection in a menu, you have performed the film-camera equivalent of changing film. And you can do this for a series of photos or one at a time; you have the choice.

- Digital cameras allow you to control light sensitivity on a picture-by-picture basis.

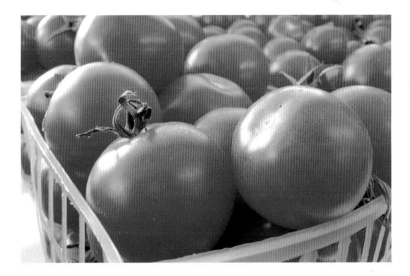

Colors Stay True

One problem with traditional photography is that the color of light affects how color looks in a photograph. Just think about all those old green photos shot under fluorescent lights—the scene never looked green to our eyes. With a digital camera's white balance control, this all changes. Now it is possible to make neutral colors stay neutral under almost all lighting conditions.

More Freedom to Shoot

When you put all the advantages of digital photography together, the combination spells freedom. You are free to shoot whatever you want, whenever you want, without restrictions of cost, color, light levels, and more. You can erase any photo that doesn't turn out well. You also have the chance to experiment with shooting new and exciting pictures that you might not have attempted if you were concerned about wasting your film.

Thanks to white balance technology, a red tomato will always look red and juicy under any type of lighting.

You can shoot from unusual angles with the handy, articulating LCDs that are available on some digital cameras.

More Connection to the Subject

Because a digital camera gives you instant feedback, you can take a picture and experience the subject, the photograph, and your feelings about the image all at once, all while you are still with that subject. This changes the picture-taking experience and gives you an incredible connection to your subject.

Rediscover the fun of taking pictures with digital photography.

More Fun Making Pictures

Digital cameras today are exciting, extremely friendly to use, and offer some totally new ways of dealing with images. This combination of more possibilities for success with the ability to experiment at no cost (including getting rid of the bad stuff instantly) usually leads to photography that is more fun!

Digital Camera Shopping Guide

Buying a digital camera is a bit of a challenge—it may seem like there is so much that you need to know in order to make a wise choice. In addition, there is so much to choose from that it is easy to lose track of key criteria in the heat of the buying moment.

Digital cameras are often grouped into types such as point-and-shoot or SLR. Within these categories, there are various levels of sophistication and different price points.

Here is a quick look at the important buying considerations so you'll understand how digital cameras work and what features you really need, whether you are buying your first or upgrading to something new.

Mini digital cameras

Mini Digital Cameras

Most manufactures offer very small, well-designed, often stylish, mini digital cameras. These can be divided into several categories based on features and operation. They also come in various sizes, from the super-mini that fits a shirt pocket to the larger, but still handholdable, zoom cameras. Be careful of the really small cameras because the LCD may be so small that it you can't see it very well.

Basic Point-and-Shoot Cameras: These totally automatic cameras are designed for casual photography. They basically offer few operational choices beyond simply turning the camera on and off. Some don't even have zoom lenses. These cameras generally have lower megapixels and lower quality lenses because the people who buy them don't expect to make big prints. Camera speed and processing capabilities are limited and lag time is usually very noticeable.

Standard Point-and-Shoot Cameras: Beyond the basics, these cameras offer more operational control than merely on/off, and are often purchased as a second camera for casual shooting or the use of other members in the family. Designed for light usage, these models generally feature lower megapixels but sometimes include better quality lenses with zooms. Camera speed and processing capabilities are limited and lag time is usually noticeable.

Sophisticated Point-and-Shoot Cameras: These offer a significant step up in capabilities and design. Cameras in this group may feature higher megapixels, white balance options, ISO setting flexibility, multiple exposure modes, multiple focus modes, expanded zoom range, and special features such as weatherproofing. Camera speed and processing capabilities are improved and while lag time is still significant, it is reduced.

Advanced Compact Cameras

Cameras in this group are generally a step up in capabilities. Their high megapixels and features rival those found on some digital SLRs but their size is smaller than a digital SLR. These cameras combine easy-to-use auto functions with a wide range of choices for white balance, ISO settings, exposure modes, plus specialized modes for focus and color balance. These models include both built-in and external flash capabilities. With wide zoom ranges and excellent quality, their lenses are often made with pro-level materials. Camera speed is the best, short of digital SLRs, and processing capabilities are superb. While there is still slight lag time, it is manageable. These cameras are designed for moderate to heavy amateur shooting requirements.

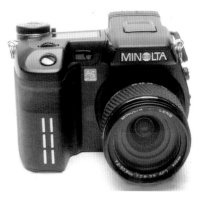

An advanced compact digital camera.

A digital SLR camera

Digital SLR Cameras

Digital single-lens-reflex (SLR) cameras offer through-the-lens (TTL) viewing, interchangeable lenses, and other advanced features. Manufacturers often offer several digital SLRs to meet multiple requirements:

"Pro" cameras are designed to appeal to professional photographers. They are generally heavy, quite expensive, and their controls are not necessarily designed for ease-of-use.

Digital SLRs marketed to the advanced amateur typically include all-metal bodies, moderate moisture and dust sealing (not weatherproof, which means it can have a built-in flash), moderate camera speeds, and high-speed autofocus.

Digital SLRs for the family or mass market are generally smaller, easier to use, and relatively less expensive. They usually have slower camera speeds and less sophisticated autofocus. This is tricky, though, because a camera introduced today in this category may easily beat many features of more expensive cameras introduced a year ago.

All digital SLR cameras accept accessory flash units, interchangeable lenses, filters, and other accessories. Due to the reflex viewing system, these cameras do not allow you to preview an image on the LCD monitor before taking the picture (i.e., there is no live preview). However, the LCD monitor can be used for reviewing recorded pictures and for in-camera image editing.

Check These Features Before Buying

Megapixels

Remember that resolution mainly affects how big your images can be. More megapixels will capture more details but, unless the photo is made into a large print, they might never be seen. Usually the higher megapixel cameras offer the most advanced features, so even if you don't need the megapixels, you may want the features.

Electronic Viewfinder (EVF)

Similar to viewfinders found in camcorders, these use a miniature LCD monitor that is magnified as it is seen through an eyepiece. This can take a little getting used to. When buying a camera with this feature, make sure the image looks smooth, has good brightness and contrast, and color looks realistic.

LCD Monitor

This important feature is what makes the digital experience work so well. However, some small cameras have too small an LCD to be truly useful. Turn it on and be sure it has good size, decent brightness and contrast, shows good color, and is easy to view.

Handling

This is an extremely important part of a camera selection process. You really have to hold the camera, try the controls, and see how it feels. A chart of features will never tell you this. If you don't like the way a camera feels or handles, you probably won't enjoy using it and your results may not be as good.

• When shopping for a new camera, hold it in shooting position and make sure that its controls are comfortable to operate.

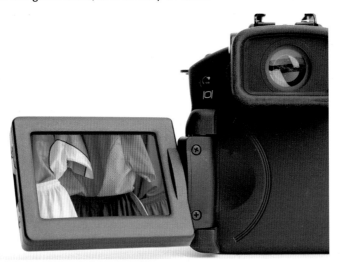

• Some camera LCD monitors flip-out and rotate, making them easier to see.

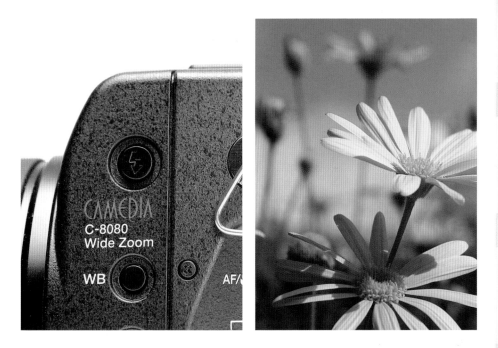

● Check out the operation logic of controls and functions; make sure the camera offers features that suit your style of photography.

Ease of Use

Controls from one digital camera to another are neither consistently placed, nor are operations controlled by a uniform set of dials or buttons. Since we all handle cameras in different ways, how controls are accessed for logical operation is important. Are they easy to find and use? Check to be sure the menus are clear and easy to read, as well.

Features You Need

Think seriously about the type of pictures you like to take. You may find that you need special capabilities such as close-focusing, minimal shutter lag, noise reduction for long exposures, built-in flash controls, second-curtain flash sync, slow flash sync, bulb exposure, and so on.

The Camera System

Various manufacturers of digital cameras offer different choices of add-on lenses, flash units, and other accessories. Different brands of digital SLRs offer a variety of approaches to similar accessories. Before deciding upon a particular brand, make sure the accessories you need are available.

The Sensor

This is the light-sensitive part of the camera that reads the scene as focused by the lens. All sensors are composed of an array of tiny light "photo sites," made of photodiodes that produce electricity when stimulated by light. These sites represent the smallest picture particle, or element— the pixel. Usually sensor resolution is measured in effective pixels, which is the actual area being used by the camera for photography.

Some small, compact digital cameras have megapixel specs that are similar to or higher than some digital SLRs. However, these smaller cameras feature physically smaller sensors than those found on digital SLRs. Small sensors have less exposure latitude and potentially exhibit more noise. It is harder to get a clean, noiseless image from a small camera, especially with low light and high ISO settings. However, in good conditions with low ISO settings (usually 100 or less), these cameras can offer images that rival much larger cameras.

Camera Speed

A combination of factors play a part in how quickly a camera takes pictures.

Boot-Up Time: This is the length of time it takes after a camera is turned on until it is actually ready to shoot an image.

Lag Time: Lag time is the delay between pressing the shutter release and when the camera actually goes off. This period varies tremendously among digital cameras. A long lag time can cause you to miss potential photos because the subject might

If you dream of taking great sports photos, you need a fast camera with minimal shutter lag and quick autofocus.

change in the time between when you release the shutter and when the image is actually recorded.

Buffer and Processing: Processing determines how fast a camera can capture the data from the sensor and move it to the internal buffer, where it is stored until the camera automatically downloads it onto the memory card. This will be expressed in frames per second (fps).

Once the camera's internal buffer is full, the camera must stop taking pictures until space is opened up by transferring data to the memory card. On compact digital cameras, the buffer is relatively small and you might only get 6-10 photos before the camera stops. Many new advanced zooms and digital SLRs feature larger, faster buffers.

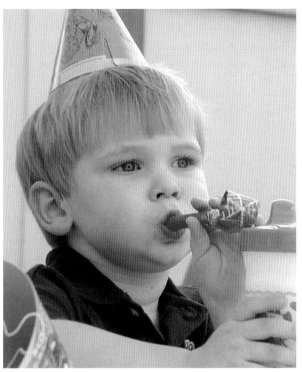

An added feature on many digital cameras is the ability to shoot video, or moving pictures.

Moving Pictures

Most small digital cameras offer a neat little feature—video capture. The lowest quality video recorded by digital cameras is 160 x 120 dpi and will play on your computer screen in a small window. That is not large enough to give decent quality on a television. Another common resolution is half the television standard, or 320 x 240 dpi. This will look okay on TV, almost as good as VHS, though still not at optimum video quality. The highest resolution is the television standard of 640 x 480 dpi. The reason for these resolutions is size—the lowest makes videos that take up considerably less space on your memory card or hard drive.

Frame rate is another important issue. The standard frame rate for video is 30 frames per second, but digital camera video will often be recorded at a lower frame rate, such as 10-15 fps. This will look a little choppier than the standard 30 fps, but it will also keep file sizes smaller. Because processing is so intense on video files, the camera may have to quit recording after a short time to catch up. This is why video from a digital camera may be limited to as short as 30 seconds.

Having a camera with video capture offers the chance to get some high-quality video quickly and easily. It is ideal for snapshot videos, to grab quick and easy video of the kids, for example. Plus, downloading the captured video is easy—just use a card reader and drag and drop the files from memory card to hard drive.

2

Noise

A clean, noise-free photograph can be a beautiful thing. Noise in an image is seen most easily in large, smooth-toned areas such as sky. It appears as tiny specks of random color and light, which can obscure fine detail and alter colors. In addition to increased ISO settings, there are several common sources of noise.

Sensor Noise

You have no control over the sensor itself (more expensive digital cameras often control noise better in their processing circuits). However, if you shoot in bright light and restrict the use of higher ISO numbers, you will minimize the noise in the image from the sensor.

Exposure

It is important to expose images well so that dark areas have enough data for you to work with. Dark areas are very susceptible to noise.

JPEG Artifacts

Utilizing a JPEG compression in the camera that is too high, or repeatedly opening and saving a JPEG image in the computer, can create blocky details that look like chunky grain—noticeable in areas that have slight gradients of tone, such as sky. Set your camera to its best quality (lowest) compression.

Sharpening

Sharpening in the camera and the computer can overemphasize noise. All too often, when the entire photo is sharpened, slight noise suddenly gets very ugly. When possible, sharpen only in the computer, and even then, only the well-focused parts of the photo.

Image Processing

Image-processing software can increase the appearance of noise. Overuse of Hue/Saturation, for example, will dramatically bring out undesirable grain, so use the software's preview and watch for unwanted noise. Avoid over-processing of an image's color.

Proper exposure using lower ISO settings will result in excellent quality digital photos like this.

The White Balance Function

A totally new control for most photographers, white balance is important to understand because it can be both a corrective and creative tool. Once you see the benefits of white balance, you will be glad that you have mastered its use.

The Color of Light

Our eye-brain connection makes most types of light look neutral so that colors stay consistent. A white shirt looks white to us whether it is in the shade, in the sun, or indoors under fluorescent lights. Yet those three lighting types have very different inherent color, which cause color shifts in photography. To keep colors looking as they should in different types of lighting, digital cameras use the white balance control.

How the Camera Adjusts

To achieve white balance, the camera looks at the white and neutral colors of a scene, either automatically or with your help, and makes them appear neutral. This control renders color accurately, making it look correct in a scene regardless of the light source, whether indoor fluorescent or mid-day sun.

But sometimes it can go too far, making the warm light of a sunset, for example, technically "correct" yet lacking the warmth we expect in a photograph of a sunset.

It is true that you can make color adjustments in the computer, and if your camera lets you shoot RAW images, you can totally change white balance after the fact. However, in most cases it is best to adjust your white balance while you are shooting.

Automatic White Balance

Automatic white balance can be useful for shooting quickly in changing light conditions, however I rarely select auto as my standard. The auto setting often gives inconsistent results simply because it is an auto function that is making the best of a world that varies in terms of color and light.

White Balance Presets

All digital cameras come with a package of preset white balance settings. To get the most from these, think beyond the preset's specific name. You may find that your camera does a nicer job using one over another. Try the different presets on the same subject to see what they do and think how you might use them beyond their specific names. The camera's LCD can help you roughly judge the different settings on a particular scene. It is true that the little monitor on the camera isn't that accurate for judging all colors, but it can give you a good idea of what the colors are doing in a given situation.

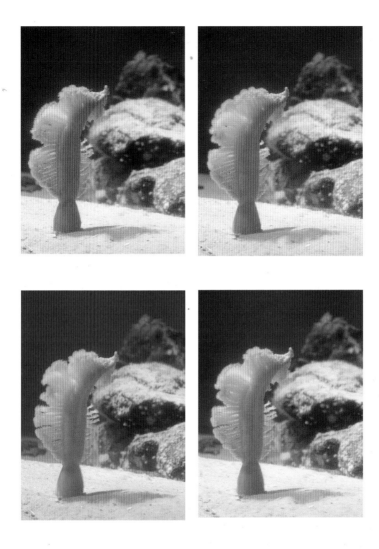

This series was taken using different white balance presets. Top left, Auto; top right, Daylight; bottom left, Tungsten; bottom right, Fluorescent.

White Balance Presets as a Creative Tool

You can also change the response of the camera so that color is rendered warmer or cooler for creative purposes. In this way you can create a sunset that looks more like you expect it to look (use the Cloudy or Flash presets). Also, you can intentionally make a cold winter day appear even colder (try Tungsten). Experiment with different white balance presets and check your LCD to see what they do to the picture.

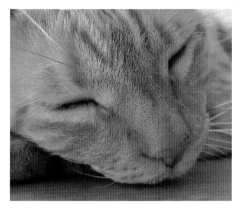

White balance should be used both as a corrective and creative tool. The cat (above) looks natural under incandescent lights with Tungsten white balance. The wall and shadows (below) were warmed up by using a Cloudy setting. And the Flash setting makes the colors richer on the leaf (right).

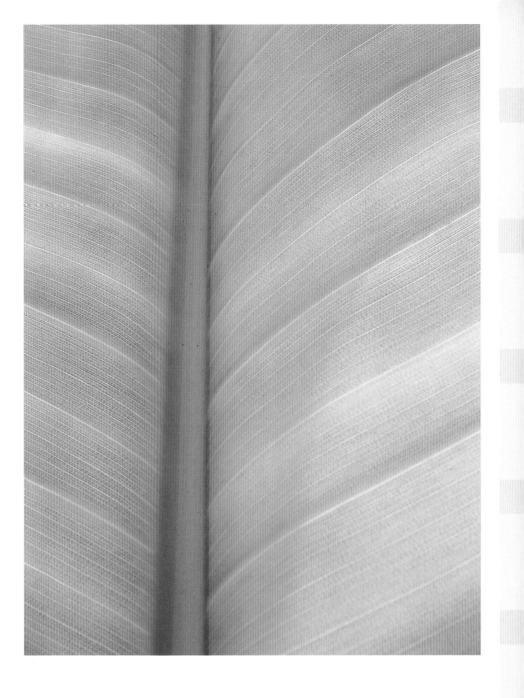

Custom or Manual White Balance

Another level of white balance control is the custom (or manual) setting available on more advanced digital cameras, but sometimes missing from simpler cameras. Custom settings can be very helpful to precisely match a given lighting condition.

To do this, point your camera at something white or gray (it does not have to be in focus) and follow the procedure for color balancing. The camera analyzes the specific white or gray tone and adjusts the color so that it is truly neutral. This can give quite remarkable results in tough situations with lights such as industrial fluorescents.

The most accurate way to handle a mixed lighting situation is with the camera's custom white balance function.

Get the Most from Your Camera

It pays to gain a certain level of understanding about different camera functions and accessories. You don't have to become a "professional" to enhance your camera's (and your) ability to shoot good photographs, but it helps to comprehend and appreciate the fundamentals.

Autofocus (AF)

Autofocus performance has a number of important attributes: speed; single or continuous focus; number and location of sensors; and AF light sensitivity. Advanced cameras usually do these better, but this is not simply a matter of camera price, since newer AF technologies often enable lower-priced cameras to beat older, more expensive cameras.

Speed and Type of AF

Speed of the camera is affected by the type of autofocus selected: single or continuous. Not all cameras will allow this choice, however. In single-exposure autofocus, the camera will not take a picture unless the autofocus has focused on something, which is fine for most shooting but can be a problem with moving subjects. Using a camera that only has single-exposure AF, you'll often get frustrated because it won't let you take pictures when it has trouble focusing. Continuous focus lets the camera shoot as it is focusing. Some advanced cameras even use something called predictive AF that allows the camera to keep up with the action. This is most common with digital SLRs and is not very common with small digital cameras.

It is possible to get very good shots even when the action is quick, but you must anticipate the action and "pre-focus" by locking the AF on something where you expect the action to go (this is especially important with non-SLR digital cameras). This takes a little practice, but the neat thing about digital is being able to review action shots on the LCD. You can check your shots and learn quickly how to best capture the action in front of you.

• You need to anticipate moving subjects and press the shutter to start autofocusing before the subject gets to the picture point.

- On some cameras, you can select the AF point in use. Make sure that it is targeted on the subject of the photo.

AF Sensor Location

Location of the actual focusing sensors in the image area also affects how the autofocus will work. More advanced cameras will have either a group of sensors across the viewing area or variable sensing over the whole scene, which makes it difficult for the subject to elude detection. Some cameras even let you set the sensor for specific areas to match a composition you want. Lower-priced cameras may have only one sensor for the whole scene—that can make it harder for the camera to find and lock focus, so you, the photographer, may have to do more work by always moving the camera slightly to be sure focus is found by the sensor.

AF Considerations

One last thing to consider is how bright the conditions are. Low light or low contrast subjects can make it very difficult for the camera to autofocus. Even the least expensive of the more advanced cameras typically have AF assist beams that operate in dark conditions. Be aware that these can be inappropriate for some locations (where a bright light in the dark would be rude or even dangerous).

- In low light and low contrast situations, your camera's AF assist may use a special light to help it focus.

Exposure

Exposure has become so automatic that in order to get poor results you almost have to try to shoot a bad picture. Cameras and their metering systems really do their job remarkably well. However, sometimes a "good" automatic exposure from the camera isn't actually the best exposure for the subject. To get an exposure that truly expresses your intent, there are things you can do to transform a good exposure into the great image you want.

Understanding Meters

A camera's meter is calibrated to expose all scenes as middle gray, or average. It can't really tell if a scene is filled with objects that are light, midtone, or dark. Ideally, under the same lighting conditions, the meter should expose all the objects equally. Unfortunately, the meter will in fact give different exposures, making light objects too dark and dark objects too light. To compensate, camera manufacturers have developed rather sophisticated systems for metering that include multiple metering points and computing analysis. These systems get more sophisticated as the price of the camera goes up.

Exposure Compensation

For most photographic situations, the camera's smart metering system offers excellent exposure. Problems occur when the scene is mostly very dark or very light, when there is extreme contrast in the scenes, and

- Don't be afraid to kneel down and take a different look at your subject—the results are often more interesting than the usual view.

when a bright light (like the sun) shines into the lens, especially when it is near an AF focusing point. Once you understand how your meter reacts to light, you can use the exposure compensation feature, if offered by your camera, to make a quick adjustment and continue to shoot automatically. Exposure compensation allows you to increase or decrease the camera's autoexposure in small steps (usually in 1/3-1/2-stop increments—some cameras let you choose the interval, some only offer one choice).

Exposure Lock

Most digital cameras will lock exposure on what-ever they see if you depress the shutter re-lease slightly (usually about halfway). This is another way to quickly "compensate" for problem scenes. For example, sup-pose you were shooting a sunrise, but a large part of the scene had a darkly silhouetted rock. In ad-dition, the camera focused on the rock. That large dark area connected to the focus point would likely throw the meter off, resulting in the sunrise starting to lose color (from too much exposure).

With standard digital cameras (not SLRs), you can see this happening in the LCD. You can then move the camera so it sees more sky and less rock, and lock the exposure when you see the color in the sky improve. Then you reframe the picture like you wanted in the first place. Some cameras have specific exposure lock buttons, too. With a digital SLR, you have to first take the shot and then check the review.

Exposure Modes

Most advanced digital cameras on the market offer multiple autoexposure modes that use the complete metering system to give you a good exposure. These modes feature approaches to exposure that meet varied needs of photographers, but you don't have to use them all. Few photographers do.

Full Auto and Picture Control Modes

Sometimes called a "point-and-shoot" mode, most cameras offer a full auto mode. Full auto rarely allows exposure compensation or any other adjustments. This is a great mode for casual family snapshots or vacation photography.

Many cameras also include special full-auto modes sometimes called Picture Control or Subject modes, which are designed to work with specific subjects such as Portraits, Landscapes, etc. These usually affect more than just exposure—such as flash, focus, and focal length.

Portrait: This mode favors wide lens openings and longer "portrait" focal lengths to render the face in soft-focus with diffuse backgrounds.

Landscape: Designed for scenic photography, this mode selects small apertures and wider focal lengths for maximum angle of view and depth of field.

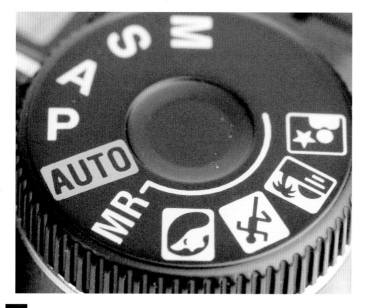

- The camera's picture control modes were used for the pictures on these two pages. These auto modes are designed to give good results with common subjects.

Action or Sports: High shutter speeds are chosen to stop action.

Flash-Off: This mode is helpful for long exposures without flash.

Night Portrait or Slow-Sync Flash: These modes balances the foreground flash and existing-light background exposure so that backgrounds do not appear dark in the photo. It is also useful for more than night photography (try it on people on a gloomy, cloudy day, for example).

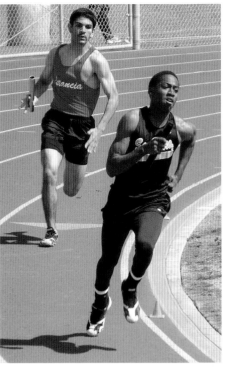

Close-Up: This mode sets a moderate aperture to balance a faster shutter speed (to minimize the effects of camera movement during the exposure) for close focus work.

User-Controlled Exposure Modes

Many digital cameras offer additional, more sophisticated exposure modes.

Program Mode (P)

The camera sets both the aperture and shutter speed for you. If your camera allows Program Shift, you will be able to quickly change the camera-selected shutter speed and aperture combination while maintaining an equivalent exposure.

Shutter-Priority Mode (S or Tv)

You select the shutter speed and the camera sets the aperture for you. This allows you to control how action is rendered in the photograph.

Aperture-Priority Mode (A or Av)

You set the aperture (lens opening) and the camera chooses the shutter speed. This gives you control over depth of field. All else being equal, smaller apertures (larger f/numbers) max-imize depth of field. However, you must be aware of the shutter speed the camera is selecting to prevent the possibility of unsharp pictures due to camera movement.

Automatic Exposure Bracketing (AEB)

Offered on some advanced cameras, this feature can generally be used with Program, Shutter-Priority, and Aperture-Priority modes. The camera's exposure bracketing system automatically varies exposures in a series of three photos, which deviate by a set range from the metered value. This gives you exposure choices in the finished images.

Manual Exposure (M)

If offered on your camera, manual exposure is useful when you have tricky lighting, when shooting panoramic photos where side-by-side photos must match, when you are trying to match flash with existing light, or for creative effects.

Some cameras offer several metering options for Manual mode, like center-weighted and partial metering. Center-weighted systems favor the meter sensors in the center of the photo, then decrease in sensitivity toward the outside of the frame. Partial metering focuses on a small spot in the image area (usually the center).

Beyond "Good" Exposure

The best exposure for a digital camera is the one that gives you the best image/data for its intended purpose. If you want to make a great print, you need to have the appropriate exposure data for highlights and shadows that can be edited in the computer. If you want to make a print directly from camera to printer, you need to know what works best with the printer (e.g., does it make prints lighter or darker than the version on the LCD?).

Also important is how exposure affects the subject. A dramatic but dark mountain might look weak and washed out when shot with a basic autoexposure mode. Similarly a bright beach might look dim and less than sunny with a standard meter reading. You need to interpret your exposures, and here again, the LCD comes through with a technological advantage.

Using the LCD and Histogram

One of the truly great advantages of digital cameras is their ability to let you review exposure on the LCD. It can quickly tell you if a scene is so contrasty that you cannot capture all the possible detail. It will show you if the subject has been captured appropriately: Are the dark trees dark and white buildings bright? It will give you ideas to change exposure to match the needs of the scene. It helps you decide if the photograph is going the way you want it to. If you enlarge the image, you can usually see if needed detail exists in highlights or shadows.

However, there will be situations when the little LCD monitor isn't as ideal as you'd like for evaluating exposure. That's when the histogram is used. While expected on advanced cameras,

it is surprising how often a histogram shows up on lower-priced cameras.

The histogram is a graph that tells you about the exposure levels in your shot. For photographers who are new to digital, the histogram's techy graph look can initially be confusing or even intimidating. My suggestion is to try it! At its basic level, the histogram is simply a graph of the number of pixels with specific brightness values from dark (on the left) to bright (on the right).

Many cameras offer a histogram readout—a graph on the LCD monitor that tells you about exposure levels. This may look confusing at first, but try it! With a little practice the histogram is actually fairly easy to understand.

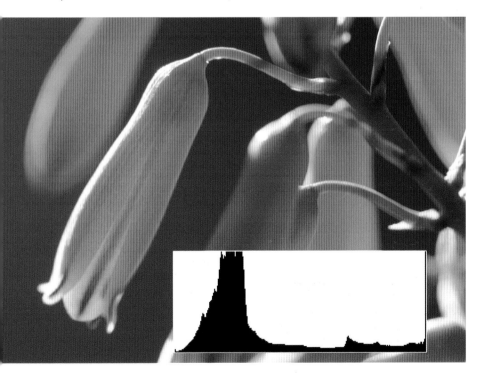

• The histogram is a very important tool for helping you get the best exposure. The key is noticing where the chart sits at the right and left sides of the graph.

How to Interpret What You See

A good exposure of an average scene will show a histogram with the graph above the bottom line from left to right, without an imbalance of brightness values on one side or the other. The range of tones for important brightness areas of a photograph should finish before the end of the graph at one side or the other. Whenever the histogram stops like a cliff instead of a slope at the sides, it means the exposure is "clipping" detail. If detail is important for dark (left) or bright (right) parts of the photo, you need to adjust exposure to bring the slope of the histogram back into the graph.

How the detail in the histogram is arranged can also help you evaluate your exposure. If you're photographing a bright scene, the histogram should show most of the values to the right, where bright values are expected in a histogram. Since bright subjects can be easily underexposed, those values may at first sit to the left half of the histogram. This is the wrong place for them. For dark scenes, the story is similar—these values belong on the left. The graphed values should reflect the scene. Use exposure compensation in automatic modes to shift the histogram to the right or left.

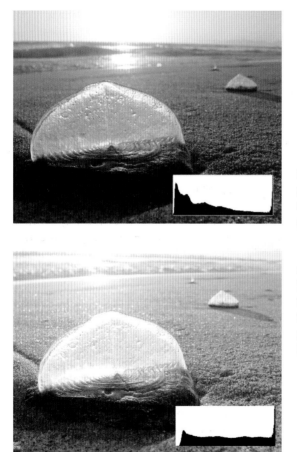

- The top photo is properly exposed and detail is good throughout, which shows in both the image and the histogram.

- The bottom photo is overexposed. Highlight detail is blown-out—this shows in the histogram, which is clipped to the right. The gap in the graph at the left shows that the blacks appear gray in the photo.

For cameras that use them, AAs are obviously an important resource, however, alkalines are really not of much use. They lose power quickly and they cannot be recharged (although the special alkalines marketed for digital products do last longer and can be used in an emergency). Nickel-cadmium (NiCd) batteries can be recharged, but aren't usually recommended for digital camera use.

The two best AA battery types for photographers are rechargeable nickel-metal-hydride (NiMH) batteries and non-rechargeable lithium batteries. NiMH batteries hold and release power well for digital cameras and can be recharged again and again. Their major disadvantage (true of all nickel-type batteries) is that they lose power just sitting. If you didn't use your camera for a month, you might discover your battery has a very short life—even though you just charged the batteries before you put the camera away. NiMH batteries will not give you their best right out of the package, either. They need to be charged and discharged a few times before they reach their full capacity. Sometimes photographers are disappointed in them after using them once, yet the batteries really aren't "conditioned" yet. Their capacity can even double after a few charging cycles.

Charging Batteries

How a battery is charged does affect its life. High-speed chargers are great when you are in rush but they will shorten the overall life of a battery. Sports photographers have discovered that they need to have back-up batteries if their rechargeables have been used hard for a while (both in the shooting and recharging) because they can just quit. Use standard chargers when you can to get the longest life from your batteries.

Back-Up Batteries

Lithium AAs are a great companion to NiMH and do hold their power just sitting—so you can buy a pack, throw it in your bag, and expect it to work years later. They are more expensive for a one-use battery (typically 2.5 times the price of standard alkalines) but they have 5-7 times the life (and actually offer much more life than even charged NiMH batteries). Lithium batteries are a great choice for back up and special conditions. They are lighter in weight than other AAs, work better in cold weather than most batteries, and will even last a long time under casual usage.

Since batteries are essential to digital camera operation, it is important to have multiple sets of batteries. Personally, I feel uncomfortable without at least three batteries (or sets of batteries) per camera. They don't take up that much space and I don't ever want to be caught with a dead battery just as I am ready to shoot.

Lenses

Varied focal lengths, whether incorporated in your camera's zoom or from interchangeable lenses, give you more capabilities in getting the shots you want. Wide-angles let you photograph in limited spaces or allow you to capture open landscapes. Telephoto focal lengths are just the opposite of wide-angles with their ability to zero in on a scene, magnifying it in the viewfinder and at the sensor. They also allow the photographer to step back from the subject and still get a reasonably sized image.

The industry uses an important convention to talk about lenses with digital cameras: 35mm equivalents. A lens' focal length is meaningless without a reference to the image area, or frame size, within the camera. Different digital cameras will have different imaging areas, which makes any comparison of focal lengths between two cameras a real challenge unless there is some direct baseline. This is the 35mm equivalent, giving a number that shows what a lens offers compared to the same angle of view as a lens on a 35mm camera.

Lens Speed

Lens speed refers to how much light a lens lets into the camera at its widest aperture—the maximum f/stop. This is the number that is always given when referring to a lens and its focal length. For example, a digital camera with a 35-105mm (35mm equivalent) f/3.5 would be a zoom lens with a maximum aperture of f/3.5. The wider the aperture, the faster the lens. A faster lens lets you use faster shutter speeds (or lets the camera select these speeds). This helps when you need to shoot action, obviously, but it also helps when the light gets low.

• A zoom lens is handy because it provides a variety of focal lengths. The photo on the left was shot with a wide-angle setting to capture a scenic vista. The photo on the right was shot with a telephoto to get in close for a detailed look at the subject.

Accessory Lenses

Digital cameras will often have a focal-length range that may not be as wide as you want and may fall short of long telephoto focal lengths needed to photograph wildlife or sports. With digital SLRs, you can buy additional lenses, and with most advanced digital cameras you can purchase accessory lenses that increase the amount of wide-angle and magnify the telephoto end. These accessory lenses can be very good and relatively inexpensive.

Besides focal length changes, accessory lenses can help with close-ups, too, both on small digital cameras and interchangeable lenses for digital SLRs. They transform your camera-zoom into a macro zoom. I am not talking about the inexpensive close-up lenses or filters, but about highly corrected achromatic, multi-element close-up lenses. While most digital cameras do have close-up settings built-in, this typically is very limited at the telephoto settings. These close-up lenses let you use all focal lengths at macro distances for great close-ups.

Lens Savvy

There are many lens applications that make significant differences in your photography. Of course, with a digital camera, you can check the results of any changes in the use of your focal lengths in the LCD and determine how best to apply the following variables.

Angle-of-View: Most people select a focal length based on the angle of view of the lens. If you are traveling and expect to be taking pictures in confined spaces, nothing but a wide angle will do. If you are photographing a soccer game where the action takes place from near to far, you'll need a zoom lens that provides a whole range of angles of view. With wildlife, a telephoto is critical.

A variant of angle-of-view is magnification. Sometimes you really do want to think about magnifying a shot—getting a closer shot of a tiger at the zoo or finding an architectural detail in the ceiling of a cathedral. Since you cannot physically move closer to such subjects, the only way to do this is by magnifying the image.

• Many digital cameras accept accessory lenses, which extend their range.

Perspective: Perspective is a major tool for image control, is affected by focal length choice, and is therefore heavily used by pros. It is one skill that sets off their images from everyone else's. Perspective is how we see size and depth relationships of objects within a picture.

Simply zooming your lens in and out does not change perspective. Perspective is a function of distance plus focal length. The trick is to move as you zoom, so the subject stays the same size, but the background changes. This requires you to move closer with the wide-angle shot because the lens will see more in the scene. Or you will have to back up with the telephoto since otherwise the lens would see a smaller section of the composition, missing the right amount of the foreground subject.

Now you'll discover some magic has been performed. While the subject stays the same, the background is different! The wide-angle shot makes the distant parts of the scene appear smaller and more distant, while the telephoto makes them appear bigger and closer.

● Wide-angle lenses exaggerate perspective and can be used to create an intriguing view of an ordinary subject.

Depth of Field

Depth of field is the range of sharpness from front to back in a photograph. It is what allows you to have both a flower in the foreground of a photograph and the mountains in the background in sharp focus. Four things influence depth of field: f/stop, distance to the subject, the size of the print, and the focal length.

Controlling Depth of Field
There are several different ways to control depth of field:

1 **f/stop:** Small lens openings (the big numbers such as f/11) increase depth of field, and large apertures (such as f/2.8) decrease depth of field.

2 **Distance:** The farther you are from the subject, the greater the depth of field. The closer you get, the shallower depth of field becomes. (This makes close-up photography a real challenge at times.)

3 **Size of the print:** Small prints appear to have more depth of field, and as you go to larger prints, the differences in sharpness among various parts of the photo become more noticeable, so apparent depth of field decreases.

4 **Focal length:** Wide-angle focal lengths give greater apparent depth of field, while telephoto focal lengths reduce depth of field. When you need to have a scene appear sharp from close to far, use the wider settings of your zoom or add a wide-angle accessory lens. If you want to limit sharpness through a selective focus technique (where one point is sharp and everything else is out of focus), try using a telephoto setting or a telephoto accessory lens.

• By using a small aperture (high f/number) and a fairly wide lens, you can get a lot in focus in a scenic shot. Here, both the rock formation (foreground) and the horizon (distant background) appear sharp.

Maximizing Image Sharpness

Many photographers get less sharpness in their images than their equipment is capable of delivering. This is really a shame considering the high quality of lenses today, and it results from a very common problem: slight camera movement during the exposure. On a good tripod, this doesn't happen. When you are handholding a camera, it is free to move or "shake," especially with small, lightweight digital cameras. A fast shutter speed will "freeze" the movement to maintain sharpness, but at a certain point the shutter speed will not be fast enough and blur will occur.

Just because a digital camera is easy to handhold doesn't mean it will automatically produce its best results that way. Unfortunately, a small LCD screen can be very misleading with sharpness. To accurately judge sharpness, magnify the image (use the magnification feature of your camera). The best way to see how sharply your handholding technique captures an image is to compare the handheld shot to a photograph taken with the camera locked on a tripod.

The solution when you are handholding? Use fast shutter speeds. Shutter speed can be a problem when photographers shoot totally automatically and assume the camera is taking care of the right speed. A slower shutter speed may be selected by the camera. This slower shutter speed may be the cause of unsharpness from handholding. Thus, you need to be especially wary of shooting in low light with the telephoto settings of variable aperture zooms and be sure you have a faster shutter speed.

- Some digital cameras offer an image stabilization feature (above). With or without this, always use good handholding technique: Hold the camera's grip in your right hand with your index finger on the shutter release. Cradle the lens and body in your left hand, and keep your elbows in, pressed gently against your body for additional support.

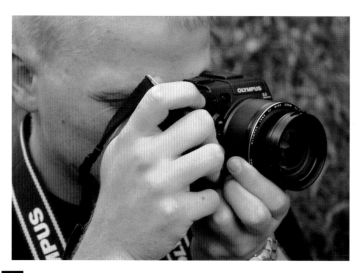

Camera Supports

When light levels drop, or you are using long telephoto or macro lenses, it can really help to use a camera support. Because compact digital cameras are so small and easy to handhold, it is easy to get lulled into the idea that they should be handheld.

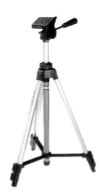

You can get very handy, compact tripods for small digital cameras that will fit in a carrying bag. These are small, but they can be set up anywhere—on a table, a rock, against a wall, and so forth, and they'll help a lot. Bean pods are quite handy little devices that fit in most camera bags. They provide a soft medium that cushions and stabilizes the camera on a hard surface, such as against a railing or fence post.

There is no question that tripods will help you get the most out of your camera and lens, but you need to invest in a good one. A cheap, flimsy tripod can be worse than none at all. And don't look for a tripod with a long center column—they are extremely unsteady.

- Essential for close-up work or long exposures, a good tripod is one of the best equipment investments you can make if you are seriously interested in photography.

Flash Made Easy

Handy flash units are built into nearly all compact digital cameras, plus you can add an accessory flash unit to any digital camera that has a hot shoe. Both manufacturers' and camera brand-specific units marketed by independent companies work with all the bells-and-whistles you'd expect in a modern flash unit. (If you are not sure if a unit will work with your camera, check with your photographic dealer.)

And you may be surprised at how much you can do with a built-in flash. You have a secret weapon compared to the days of film: Take a picture and check it! Your digital camera gives you the actual image on the LCD.

Basic Flash Exposure

The digital camera will send off a burst of light called a preflash an instant before the flash exposure actually occurs. The preflash allows the camera to determine the exposure. This happens so fast that most people don't notice. For the actual exposure, the flash emits a specific duration of light and cuts itself off when the proper amount of light has been cast.

Red-Eye Reduction Flash Settings

Red-eye in flash photos of people is distinctly unattractive. It occurs in dark situations when flash is used. On small digital cameras with built-in flash, the flash is so close to the axis of the lens that red-eye is almost guaranteed because the flash reflects directly back from the eye.

• With digital photography, you have many options in winning the battle against red-eye.

The red-eye reduction function will either cause a preflash to occur, making the subject's iris narrow, or it will emit a light to do the same thing. While this is helpful, it can also create photographic problems. Often the subject will react poorly to this preflash, so the photos may show less red-eye, but the person's reaction creates an unflattering picture.

You can also get rid of red-eye by using an accessory flash. This larger unit is farther away from the axis of the lens. In addition, many software programs now include easy-to-use red-eye reduction tools that allow you to take the good shot and not worry about red-eye while you take it. There are even some cameras that include red-eye removal in the camera itself.

Easy Flash Options

Most photographers use a flash aimed directly at the subject. This direct type of flash is useful when you need to see things in dark conditions or when your subject is some distance from you, as with sports or wildlife photography.

Another use of direct flash is fill flash. This allows the flash to brighten shadows in very contrasty light. It is an ideal use for a built-in flash. Watch people taking pictures of each other on a bright, sunny day. Notice that contrasts create strong shadows on faces and under hat brims. Yet, although most of these people have cameras with a built-in flash, the photographer rarely turns it on. Almost every digital camera can have the flash set so it flashes at all times. Again, the great thing about this technique with a digital camera is that you can always see the results and there is no cost to experiment. Try turning on your flash in harsh or even gray-day conditions and see what you can get.

Unfortunately a lot of indoor flash photos look like those deer-in-the-headlights paparazzi images. This type of lighting isn't flattering to the subject and can produce harsh, rather unattractive photographs. There is one thing you can do with your built-in flash to avoid this: allow some existing or ambient light to be exposed in the background. (Check your camera's manual to see the best way to do this. If your camera has a slow-sync or night flash setting, try that.) This immediately makes the flash look less harsh.

If you can use an accessory flash unit, there is a very easy way to get better photos: bounce flash. It can be used with any flash that tilts, or with off-camera flash. Here, you point the flash at a white surface (ceiling, wall, reflector, etc.). This spreads the light out and softens its edges. It can be a very attractive and natural looking light for interiors and is especially effective when photographing people.

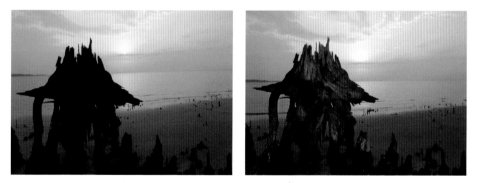

• If you are within your flash unit's range, never hesitate to use it to augment exposure. In this case, flash was used to capture foreground detail while maintaining the saturated colors of the sunset in the ambient background exposure.

4

The Ink Jet Printer

Ink jet printers have come a long way since their introduction nearly 20 years ago. At one time, they barely produced readable type, let alone photographs. Today, they let us make prints from our digital images that are as good or better than traditional prints.

To get the best prints for your needs, it helps to first understand a bit about ink jet printers and their features. This chapter will get you started on mastering the ink jet printer.

How Ink Jet Printers Work

With an ink jet printer, ink is sprayed in tiny droplets onto the paper in a particular pattern to make all the tones and colors you expect in a photograph. Depending on the brand, there are several distinct technologies for doing this, but all are capable of producing photo prints as good or better than anything you could get from a lab. The printer head runs back and forth across the paper, placing ink droplets very precisely as the printer moves the paper through in small steps. This builds the photo, row by row, inch by inch.

All manufacturers use proprietary algorithms (computer instructions in the printer driver) that optimize the image when processing the print. Top photo quality is highly dependent on a printer's ability to lay down ink in exact patterns and alignments. In addition, the resolution affects how the ink is applied. While resolution above 1500 dpi can theoretically give crisper text and finer lines than you would see below 1500, for all practical purposes, resolution above that number does little except slow down the printer and use more ink.

Ink jet printers use ink dots so small that you cannot see them with the naked eye. With the smaller droplets, print quality gets better because the printed dots can be blended more evenly and gradations of tone are smoother. These factors are often more important than resolution.

All of today's ink jet printers will make beautiful photo prints with the right paper and settings.

Printer Characteristics

Dyes vs. Pigments

Ink jet printers use either of two basic types of inks: dyes or pigments. Dyes have traditionally offered brighter colors, but are more likely to fade. For a long time dyes were the only way to print with an ink jet because they were the only type of colored ink that easily sprayed through the printing head. It was difficult to develop pigments that didn't clog the head.

Epson was the first to beat both problems. They developed a dye-based ink with improved fade resistance. They also figured out how to make pigmented ink that both flowed easily through the print head and produced bright, saturated colors, though dyes still hold a slight edge for color brilliance and speed of printing. Now, Hewlett-Packard and Canon offer dye-based inks with long life. The permanence of a photo, however, is based on more than just ink. Other important factors also include the type of paper used and how the print is displayed or stored.

Number of Colors

Ink comes in four colors: cyan (C), magenta (M), yellow (Y), and black (K). All ink jet printers have at least these four colors. While some basic four-color printers can yield very good images, printers dedicated to photo production are optimized for photography; many include extra ink colors that give exceptionally refined results and pale versions of cyan and magenta to improve color tonalities. This technique is especially noticeable in the highlights and in subtle gradations between tones. Photo printers that contain seven or eight colors do several things to enhance prints, including the addition of light gray. This helps produce better neutral tones, and increases the ability to render subtle tonal gradations, and new ink mixtures that give these printers additional color capabilities.

Speed

Printers get faster all the time, and price generally increases with speed. In looking at the speed of a printer, however, you need to understand several things. First, print speed can be limited by the computer's processing speed and available RAM, although most computers sold in the last few years have adequate amounts of both to be relatively fast. Second, since the industry has no absolute

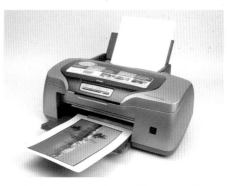

The best photo printers offer more colors and small ink droplets for top photo-quality.

standard for speed, you cannot compare different brands, just printers within a brand. Third, the industry has some conventions about the way speeds are marketed. Typically, the advertised speeds are for draft or economy mode, which you are unlikely to use with photos. No printer can produce a photo at speeds of 10 pages of color per minute. Photos can take minutes to print and still be considered fast. It is necessary to compare fine, best, or photo-quality printing speeds.

Noise

Ink jet printers make noise when warming up, printing, and cleaning. More expensive models are usually less noisy.

Borderless Capabilities

Borderless photo prints have become very popular. People expect them from their print processors. Many ink jet printers offer the capability to print edge-to-edge on the paper, especially the photo printers. The paper comes out with a full image and no trimming of white borders is necessary.

Paper Path

Printers move paper past the print head in three ways: (1) with a reverse curve, (2) a slight bend, or (3) straight through. The reverse curve printers load paper at the front of the printer, pull it in, and then run the finished print back to the front. The advantage is that less desktop space is needed, but the disadvantage is that you can't use as thick a paper as in other types. The printers that employ a slight bend to the path bring the paper in from the top and back of the printer, then send it out the front. If you want to print on very thick papers, check into some of the higher-end printers that include

multiple paper paths that add a straight-through path from back to front. This allows the printer to send paper through without bending, but it does require more space, access to the back of the printer, and must be fed one sheet at a time).

Size

Printers that can print on large paper sizes cost more. The least expensive printers will handle standard 8-1/2 x 11-inch paper just fine, but no bigger. Larger printers typically handle standard print sizes up to 13 x 19-inches. Some specialized pro printers allow for larger sizes. Also, panoramic prints are possible with many printers, but you have to check the specs.

Ink Cartridge Format

Black ink is typically sold in its own separate cartridge. Colored inks are sometimes grouped in single cartridges, or available in a separate cartridge for each color. Lower-priced printers usually have the grouped color cartridge. Individual cartridges can be more efficient if you do a lot of printing because you can replace each color as you deplete it.

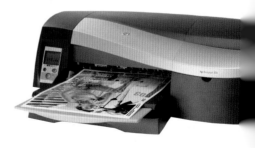

Some pros use printers that can produce prints as wide as 24 inches, or wider!

Certain cameras will connect with specific printers to allow printing directly from the camera.

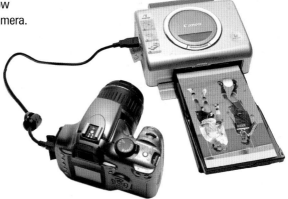

Accessories

You may have some specific needs, such as printing long panoramics or doing prints on a roll (convenient for printing lots of 4 x 6-inch photos, for example). Check to see if the printer you are considering can use these accessories.

The All-in-One Option

All-in-one printers offer multiple functions in a single unit. You can get a printer that scans photos, plus acts as a copier. Other units add fax capabilities. These can be a great benefit to the small office. You receive several helpful functions that fit in a small space. The printers built into these units can be quite good, but typically they do not produce photos that are as refined as those from a dedicated photo printer. Some, however, do include built-in memory card readers that offer a unique photo printing feature—you can print a proof sheet of all the images from a memory card, mark that sheet with a pen or pencil, then scan that sheet and the unit automatically prints out the images you marked, at the size you want.

Connectivity

Previously, printers connected to the computer through good old parallel or serial ports. This was fine, but is not nearly as speedy or convenient as USB. USB connections can be "hot-swapped" or plugged in and out of the computer while it is on. This provides a fast connection between computer and printer, so that the printer doesn't have to wait for data.

Direct Printing

Many printers now include built-in memory card readers that facilitate printing directly without going through a computer. If you do a lot of casual digital camera shooting and want to make prints quickly, this type of printer may be very useful to you. It has limited adjustment capabilities, however, so for prints that you really care about, you will most likely want to use the computer to process the images.

The Printer Driver

This unassuming part of the process is a vital component of printing. The wrong driver settings can totally change the look of your print. It can look like you adjusted the photo in your image-processing software, even though you never did.

The printer driver is the control portion of your printer's software. Other functions of that software include such things as a utility to check ink levels, print head cleaning, alignment, and so forth.

The printer driver dialog box appears as soon as you tell the computer to print whatever is on your screen.

Once it comes into view, you will need to make some simple but extremely important choices about your settings. You have to tell the printer what kind of paper you are using (glossy, heavy matte, plain, etc.) so it can set the proper settings for that specific type. Printer manufacturers have worked very hard to develop complex algorithms (or computing instructions) to optimize your image when printed. These instructions do their work quite well, but do require some simple choices in the printer driver.

● Setting the printer driver correctly is very important.

1. Click on Properties.

2. Select the proper paper.

3. Choosing quality setting.

4. Advanced settings available.

1

2

3 4

Key Steps for Using a Printer Driver with Windows

1 **Open the driver** by going to the print part of your program's menu, to a printer icon, or by using Command/Ctrl P.

2 Be sure the correct printer is selected if you have more than one.

3 **Click on Properties.** There may be an additional dialogue box that comes up with selections such as Setup, Printer, or Options. You may need to click on those to tell the software how to deal with the photo it sends to the printer.

4 Click on the Properties dialogue box, labeled at the top.

5 This part of the driver typically has multiple sections. The first usually asks you to choose paper or "media" type. **Choose a paper** that matches the paper in your printer. Some printers will have a choice between automatic and other modes. For much of your printing, you'll find the automatic mode works extremely well. Other sections allow you to select border or borderless prints, print orientation, and so forth.

6 **Make photo adjustments.** Many photo printer drivers will include options for "enhancing" your print. These can be good settings to try with digital camera files that have had minimal modification because they will make some adjustments to the file to brighten and intensify the image. You may also find special adjustments such as black-and-white and sepia effects. These settings don't change the image file in the computer.

7 Use a **print preview** option by checking the box if you want to see the placement of the photo as it will appear on the page.

8 Many printers offer additional choices for special printing, like putting several pages on one (this is more for text printing) or making a poster bigger than the printer's size by using multiple pages.

9 Click "OK" to accept the settings, then click "OK" on the first Print dialogue box.

Key Steps for Using a Printer Driver with Macintosh

The process for Macs is similar to Windows, so be sure to familiarize yourself with the steps above that outline Windows:

1 Open the **Page Setup** option on the menu.

2 Be sure the correct printer is selected if you have more than one in use.

3 The Page Setup box is like the paper section of the Windows driver. Here, you tell the printer the size of the paper, the paper path (e.g., the standard sheet feeder or a roll feeder), the image orientation, and how to use the area of the paper. Accept your settings by clicking "OK."

4 **Open the printer driver** (you can just go to Print in the File menu). Choose the paper or media type in Print Settings and mode.

5 Click "Print" to accept the settings and start printing.

Resolution

Resolution is a key topic, but always remember this: Image resolution and printer resolution are not the same. Image resolution refers to actual pixels in a photograph. Printer resolution refers to the way the printer puts ink down on the paper. One of the most common printing problems is printing at the wrong image resolution. This shows up on the print as less sharpness, poor gradations of tone and color, less contrast, and weaker color.

Image Resolution

In order to get the best prints possible from your ink jet printer, you must start with the appropriate image resolution. Remember 200-300 dpi/ppi. This resolution will always give you the best quality from your printer, regardless of the printer resolution.

Purists like to use the ppi (pixels per inch) term for this resolution, but most people interchange it and dpi (dots per inch). They really refer to the same thing, and 200-300 dpi/ppi is an optimal resolution range for an image. Going higher than 300 ppi doesn't enhance print quality and can actually cause problems, including poorer image quality and computer crashes.

Checking Image Resolution

Some dedicated printing programs will resize your photo automatically for any given output size. In image-processing programs such as Photoshop and Photoshop Elements, check your image size and resolution in the Resize part of your software. Image browsers usually give this information as well. You can change the

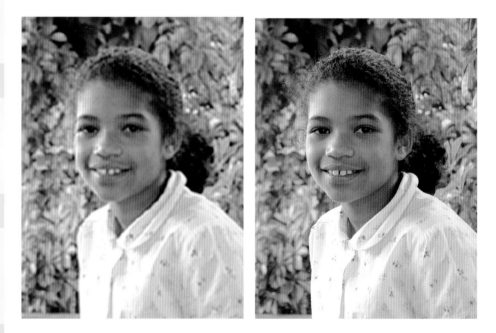

Correct image resolution is critical for a good print. The photo at left is at a web resolution of 72 ppi/dpi; at right, the image is correct at 300 ppi/dpi.

resolution without changing the file size at this point to between 200 and 300 dpi/ppi. Then, if you need a larger or smaller photo, use the Resample Image option in your software program. If you try to blow up an image too much, you will lose sharpness. Any image size change will require at least some sharpening.

Printer Resolution
Printers usually can be set with several resolutions, for example 360, 720, 1440, 2880, and 5760 dpi. Your printer will automatically set the proper dpi for the paper used as long as you correctly choose the appropriate paper setting within your printer driver. A higher dpi number usually means that the small details in your photo will be better rendered and tonal changes (the gradations between colors) are less perceptible. For most photo printing, however, you will find that 1200-1500 dpi gives you results hard to distinguish from higher resolutions. In addition, higher dpi also means slower printing and that more ink will be used.

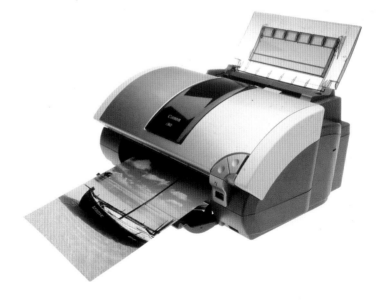

Always remember that image resolution and printer resolution are not the same.

Caring for Your Printer

The life of a printer depends on your printing needs. There is no question that expensive graphic arts ink jet printers, which often have similar printing specifications to much lower priced units, will print a large volume of prints every day without failure much longer than a value-priced printer. You do get what you pay for. However, if you only print a few photos per week, you probably don't need a high-priced printer designed for the graphic artist or wedding photographer who cranks out lots of photos.

Good color is dependent on using the right paper and setting the driver correctly. When you notice streaks or uneven colors in your image, it is time to clean the print head.

On and Off

When you turn a printer off, it parks the heads in a very specific place. If you turn the printer off at a power strip, it may or may not be parked properly. This can lead to the head drying out and clogging. Never turn off a printer with a power strip.

Cleaning the Print Head

One of the most common problems with ink jet prints is a clogged head. Typically, you'll see streaks of colors or actual lines of white where ink did not print. I've even seen clogged heads that printed oddly colored photos. This can also happen when your ink is low, so check that.

To fix a clog, you need to clean the print head. This will use up some ink, so you don't want or need to clean a head until it shows a clog and really requires the cleaning. When it does, cleaning is well worth this small sacrifice. Printers vary in how their heads are cleaned—sometimes there is a cleaning button on the printer itself. There is always a cleaning utility in the printer driver software.

Cleaning the Printer

Use a soft brush to clean dust and dirt from the sheet feeder. You can use the same brush inside the printer, but avoid the gears. A can of compressed air can be used to get rid of dust and debris, but never shake it or get the nozzle too close to moving parts. Clean ink out of the inside of the printer with a soft, slightly damp (not wet) cloth. Use a soft, slightly damp cloth on the outside as well. Never use any solvents or oils, especially cleaners with alcohol, because this can damage the plastic.

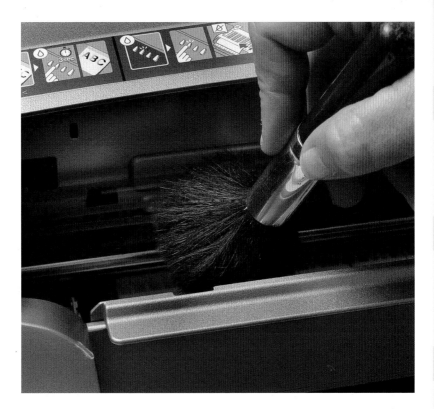

○ Use a soft brush to occasionally clean the printer and keep it running smoothly.

Printer Driver Problems

Driver failure can occur in any number of ways. If prints just never seem to turn out correctly, try removing the driver and reinstalling it. In addition, it is always a good idea to check the manufacturer's website once in a while to see if a new, improved driver or software patch has been posted.

Printing Seems Slow

Check your image size. Big, high-resolution images need RAM and hard-drive space to print. Be sure you have enough of each. You may need to add both, but RAM is especially important.

Banding or Splotchy Colors

Be sure you have the driver setting for the paper in use. Some independent paper brands can print very poorly if the printer driver is not properly set. In addition, if you load some papers incorrectly with the coated side down, you may get odd ink patterns on the photo. If the paper and driver setting is correct and you still get splotches, try cleaning the print heads, or you may need a new ink cartridge.

5

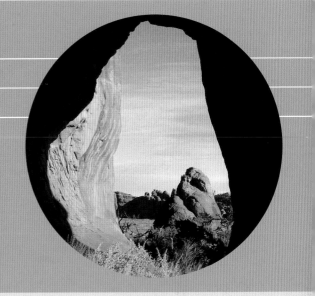

Making Great Digital Prints

Printers really need quality paper designed for photos in order to produce the best photo prints. All printer manufacturers make a variety of papers, and there is a growing marketplace of ink jet papers from many suppliers. There are a number of factors that go into choosing the right paper for your needs. In the end, this is a highly personal choice (for example, I may love matte papers, but you think glossy is the only way to go).

Paper Weight and Thickness

Every paper has a weight and a thickness. They affect how a paper can be used as well as the impression you get while viewing the photograph. The bottom line for the photographer is what you expect from your print. You need a heavier paper if the print will be handled a lot, maybe being passed around to friends and family. Brochures or flyers, too, need some weight or they'll leave a poor impression. In addition, the heavier and thicker papers "feel" more like a traditional print.

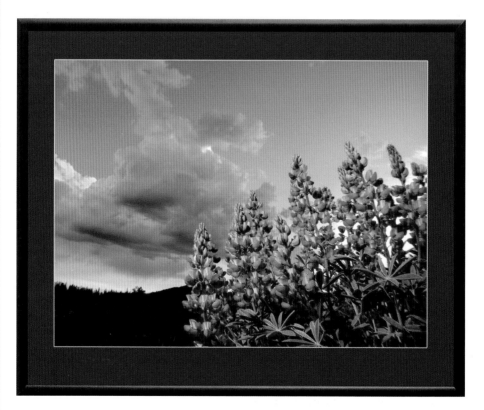

- The final use or purpose of an image will influence the type of paper you utilize, including its weight and surface.

Other Characteristics to Keep in Mind

In addition to different weights and thicknesses, paper also possesses other characteristics that affect the printed photographs.

Opacity

Opacity might be better understood if you think of it in terms of transparency. How easily can you see through the paper? If not very well, the paper has a high opacity. This becomes important when you need to put papers together (as in a booklet) or if you need to print on both sides (such as a brochure). With low opacity, you can see words or photos coming through. High opacity makes the photo stand out on the page.

Surface

The surface of ink jet paper is coated to make the ink look better when laid down as a photo. This surface can vary from very glossy (shiny) to matte (non-reflective), with variations in between. A glossy surface will give the photo the highest sharpness, the most tones and the brightest colors. A matte finish can be easier to look at because it is not reflective, and will have its own unique "patina" (surface aura) and color rendition. Some people naturally gravitate to the sheen of glossy papers, while others truly enjoy the gentler tones of matte.

Whiteness

Papers normally are rated for whiteness (or ISO brightness). Higher numbers mean whiter papers. Typically, you want paper as white as possible (rated in the 90s or higher) because that means colors will print at their brightest and the tonalities will appear at their richest. However, when using specialty products such as watercolor paper, where a warm tone is part of the appeal, a reduced whiteness value may be desirable.

Lifespan

All paper ages. It may yellow and deteriorate from exposure to light and certain gases in the air (including pollution). Cheap paper may have acids in it that can degrade the paper (and therefore the image) after a few years. Better papers vary from acid-free to plastic coated in order to minimize this problem.

Some papers are designed to work with specific inks to increase permanence. Any ink will last longer with the right paper. For archival pigments, matching archival papers exist that make a very long-lasting combination.

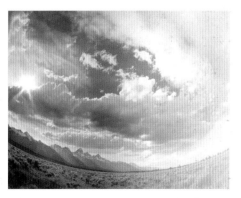

• To keep your image from fading, you need to use long-life paper with your printer and protect the image by framing it.

Different Uses

How you plan to use your prints will have an effect on paper choice. Will people hand your photos around? If so, look for a heavyweight paper. Do you plan on making brochures or greeting cards? Be sure your paper will fold. Do you want the absolute brightest colors and sharpest images? Then use a high gloss, extra white paper. Do you need to print a newsletter on both sides? Be sure the paper is coated on both sides to optimize the printing. Do you want to sell photo prints? Look for a paper that will impress your buyers in terms of feel and color, but also consider its life.

Specialty Papers

Specialty papers and printing media may offer specific solutions to your photo needs that regular papers can't provide. These range from expensive watercolor papers to special transfer papers that let you make an image that can be ironed onto a T-shirt. You can get also buy transparency film, allowing you to print on clear plastic that can be backlit or put on a window for a glowing photo image effect. There are a number of different types of papers and textures to choose from, including metallic glossy, canvas, silk, and many more.

● Special papers are available to make everything from greeting cards to decals for T-shirts.

Rolls and Sheets

A number of printers offer the capability to handle roll-paper, which makes it simple to produce multiple prints without having to deal with single sheets of paper, as well as create long panoramic images. Some printers even include an automatic print cutter that will allow you to leave your printer unattended while it prints and cuts your photos.

With borderless printing and paper rolls, it is quite easy to produce multiple 4 x 6 prints like those you get at the mini-lab, except that the printing is under your control. The printer pulls the roll paper in as needed and you get a long strip of borderless prints that are easy to cut to final size (or are automatically cut with the right printer).

• You can make panoramic prints with printers that handle roll paper or long sheets (this photo was made from three individual shots).

Manufacturer Convenience

Printer manufacturers themselves offer diverse lines of paper that help make printing convenient and consistent. This is because their printer driver includes settings directly linked to specific papers.

There are a number of fine papers being made by a variety of sources, including some paper types that you can't get from the manufacturer. Still, the manufacturers' printers and drivers are definitely optimized for their proprietary papers, which should come as no surprise since the company has a lot invested in printer quality and wants buyers to get the best from the combination of printer, ink, and paper. You will also find that some independent papers, advertised to work well with all printers, do not always live up to their claim—you have to test them.

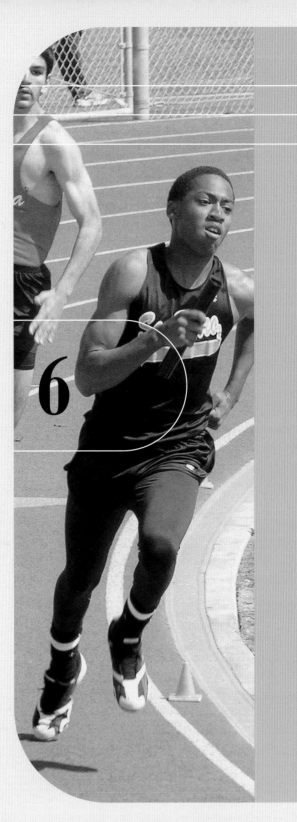

6

Preparing an Image for Printing

What do you expect from your photographs? A nice likeness, or an image that says something special about your subject? Due to the many good programs on the market for adjusting photos, you can do some wonderful things in the digital darkroom using your computer to enhance your images.

Image-Processing Programs

Among the many outstanding programs available for image processing, Adobe Photoshop is probably the best known, but it is expensive and has a steep learning curve. Photoshop Elements can do nearly as much and is more suited to the average photographer. Other excellent programs include Jasc Paint Shop Pro and Ulead PhotoImpact.

But, no matter what computer program you choose, the easiest way to get the most out of your image-processing software is to use your camera to shoot the very best photo possible in the first place, by setting appropriate exposure, the right shutter speed, sharpness, etc.

I'm going to let you in on a secret that I share in my workshops and magazine articles. You don't have to know everything about how an image-processing program works in order to use it to make beautiful prints. No matter what program you use, you are the photographer and your photo is the important thing, not the program. It doesn't matter how many filters a program offers, for example, if you only use two. If you don't need certain features, ignore them. Look at a program's features in terms of what might be useful to you. This may be hard if you're a beginner. In that case, start simply with an easy-to-use program even if it doesn't have everything possible.

You will need to take some time learning what your program can do for you and your photos. This is a craft and you will get better with practice. Still, you don't need to practice everything—learn a few tools well, tools that serve your purposes, rather than trying to remember how everything works.

Black and White Are Important

When using image-processing software, one absolutely critical adjustment tool for creating the best prints possible is the Levels control. It appears on your screen as a graph, which can look a little intimidating at first. But with just a little practice, you will benefit greatly from using it. Levels lets you set the black and the white parameters of your photo. Without a good, solid black, the photo will look dull, tonalities will be off, and colors will look weaker. Digital camera images often suffer because of this.

The Levels control tells immediately if you have a complete range of tones from pure white to pure black. Don't be intimidated by the graph display, called a histogram. It shows the distribution of brightness values, from black to white. Black is on the farthest left axis; and there is a little black triangle below. White is farthest to the right, and a white triangle takes up residence underneath.

The histogram should start rising at the far left axis and finish at the right. If there is a gap on the left and no part of the graph extends to the left edge, there are no solid blacks in the photo. If there is a gap on the right, so that the graph doesn't touch the far right side, then the highlights will be more gray than white. To adjust, you simply move the black slider on the left until it is under the rising start of the histogram, and move the white slider on the right until it is under the descending end of the histogram.

You don't have to stop here. You can continue to move the black and white sliders toward the center, either separately or together, to create contrast in your image. The neat thing about Levels is that you can create

this contrast by favoring the dark areas (left, black slider) or the light areas (right, white slider) in your adjustments.

As you make your changes to the image, the midtones, which constitute the bulk of the image, will also change. There is a third slider beneath the histogram with a gray triangle in the middle. You can make the midtones lighter or darker by moving the gray slider to the left or to the right. This is a very powerful way of dealing with an image. The midtones can now be brightened or darkened to create your vision of the subject, without affecting the blacks or whites.

Curves

Curves is another graphic adjustment tool that can help you modify the brightness and contrast of an image. However, using it effectively takes practice. It is great for adjusting contrast and midtones after you have set the black and white points. Click the cursor on the middle of the diagonal line and pull it up to lighten the midtones or push it down to darken. Usually, you don't need to move it much to see the effect.

Now if you wish to favor the dark grays or the light tones, you can click again in the lower or upper part (respectively) of the graph. You now drag the curve up or down to affect a part of the curve, which results in a more isolated effect on the tones of the photo. If the curve moves too much in an area that you don't want, click on the graph in that area to anchor it to that point.

Selections

Very often you will note that an image looks good overall, but has brightness or color problems in a specific area. By selecting that area of your photo, you can isolate your adjustment controls to that specific portion without affecting adjacent pixels. All of the Selection tools can be useful, from the shaped selection tools (rectangles and circles) to the freehand Lassos (which follow your cursor) to the very helpful automatic tools (the Magnetic Lasso and the Magic Wand, for example). With any of these, you move your cursor around the area to be selected and a selection line will appear (sometimes called the marching ants). Making good selections takes some practice.

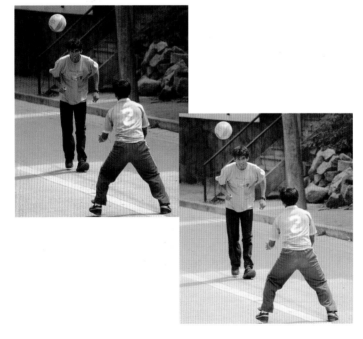

● By moving the center of the curve upward, the midtones of the photo are lightened without hurting the blacks or whites.

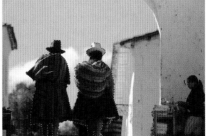

• Selections allow you to adjust part of a photo separately from the rest. Here, I took a photo of two Peruvian women (top), then selected the women for adjustment (center). The final adjusted image (bottom) shows the changes I made to the selected part of the shot.

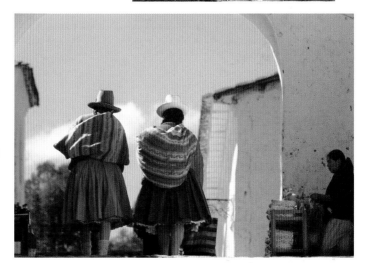

Selection Tips

1 Enlarge your image, so that you can better see edges of your subject.
2 Add and subtract from the selection in order to refine it. Hold down the Shift key as you make selections to add to the area, and the Alt or Option key to subtract.
3 Use more than one Selection tool—use the Shift or Alt/Option keys to add or subtract.
4 When you have made your selection, feather it. Feathering is a blending or smoothing of the selection edge. Selected edges are generally much sharper than those that would naturally occur in a photograph. Feathering takes that edge off.

Hue/Saturation

Almost every image-processing program lets you affect hue (the actual spectral color) and saturation (intensity). Usually there will be a slider control for hue, which allows you to change colors. This can be helpful in very small amounts to tweak the overall color of the image. You can get wild effects when the hue slider is moved a lot. You can also select a specific part of a photo, for example, a red flower, and adjust its hue, or even change the color altogether.

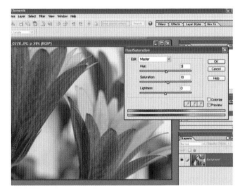

Saturation is a key color tool. This allows you to change the intensity of colors. You can adjust the whole photo to make colors more or less saturated.

Often, digital cameras produce files that print with less color intensity than you might remember from film. Try bumping the saturation up 10-15 points and see if that helps.

In a number of programs, you can actually isolate the Hue/Saturation adjustments to a particular color. In Adobe Photoshop and Photoshop Elements, for example, you can click next to where it says Edit: Master and a drop-down menu will appear with specific colors.

Color Balance and Variations

Sometimes you have a photo that is just a little off in color, sort of like a song that is sung slightly off key. It just won't print satisfactorily. You can definitely use the Color Balance controls and the Variations adjustments available in many programs to come to rescue it.

In Variations, you click on colored thumbnails to control the amount of red, green, and blue in a photo. You set the adjustment window to favor shadows, midtones, or highlights. You'll often find it works best with the intensity set low.

With Color Balance, sliders control the amount of red, green, and blue intensity in a photo. Again, you set the adjustment window to favor shadows, mid-tones, or highlights. The sliders work on opposite colors—cyan to red, green to magenta, yellow to blue—or they are set up to add or subtract the computer colors, red, green, and blue (RGB). I use something called the "Extreme Technique" to see what colors need the most adjustment. I move the sliders to the extremes to see what colors need the most adjustment, then move them to places where they work best.

Layers: New Possibilities of Control

The key to understanding Layers is to realize that they separate your adjustments into distinct and isolated pieces of an image. Think of it as putting a stack of identical photos on your desk. Each photo is a layer in that pile. When you look at the stack from above, you only see the top photo. Cut a piece out of that top photo and you can see some of the photo under it. If you keep cutting pieces out of photos as you go down through the stack, you'll be able to see parts of the lower images. If you do something to the photo under a solid layer with no cutouts, you won't see the effect because the top photo hides it.

To get started using Layers, try Adjustment Layers. This can be very helpful with printing, because it allows you to adjust what a photo looks like without changing the underlying photo. Plus, it allows you to go back later and readjust if you don't like the effect on the print. There actually is nothing in an adjustment layer except instructions. These instructions can be set to affect tonal controls as well as color. And since Adjustment Layers always work from the top layer down, they affect whatever is underneath them.

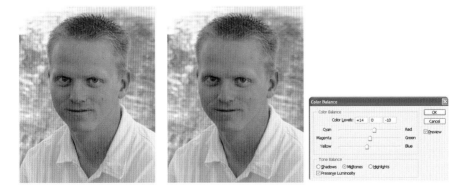

Sharpening the Image

You may also find Duplicate Layers quite helpful for printing. These are layers with identical images in them, like a stack of photos. You can experiment and try different effects on the various layers and compare them fairly easily, because all the layers are right there on your computer desktop. Since duplicate layers are separate, anything you do to one has no effect on the others, and you can compare them quite easily.

For a print to look its best, its image file usually has to be sharpened. This has nothing to do with making a fuzzy or blurry image sharp. Sharpening brings out the fine details in the file.

The best sharpening tool is the Unsharp Mask, which in spite of its name, gives a great deal of control over sharpness. (The name is actually a relic from the commercial printing industry.) This tool has three different controls that can be adjusted separately for optimal sharpness.

Once you open Unsharp Mask, you'll discover a window with sliders that control the Amount, Radius, and Threshold.

Amount: Amount represents the intensity of the sharpening effect, which increases differences along edges of contrast in the photo. Usually

• Layers give more control over an image. They work top to bottom; the top layers affect those below.

Noise Management

Visually, "noise" in a digital file is essentially the same as grain in a conventional photograph. Its irregular speckled pattern can be distracting and can destroy a good picture. When processing your photo, be aware that grain can be amplified as a result. See page 29 for additional information about noise.

• Unsharp Mask is the preferred method of sharpening because of its versatility and power.

you'll want to set a value between 100 and 200% in Photoshop and Photoshop Elements (this range does change from program to program—experiment first with the lower range of numbers). Typically, I find that digital camera photos look good in the 120-140% area.

Radius: Radius determines how much of an edge change is used in order to make the sharpening effect. Generally, this is most effective in the 1-2 pixel range, using lower numbers (they can be set as decimals) for smaller file sizes (say 10 MB or less) and higher numbers for larger files. Watch out for over sharpening, which adds harshness to the image and rings or halos of white around dark edges.

Threshold: Threshold tells the program at what contrast to look for differences along edges. Low settings give the most sharpening effect—if you can use 0, go for it. However, a low Threshold setting will cause the program to sharpen and therefore overemphasize grain and noise. Typically, a Threshold between 3-10 works well and minimizes grain problems, but you will have to increase the Amount setting.

Differences Between the Monitor and the Print

The key to dialing in that great print (adjusting your software to the optimal settings) is understanding that the monitor image and the printed image can never look identical. The reason is similar to why slides and prints from those slides will never look identical. The print is viewed with light reflecting off its surface, while the monitor shows us an image based on transmitted light of glowing red, green, and blue phosphors. Reflected light and transmitted light can never look identical to our eyes. So, we will aim for as close a resemblance as possible, given the two different technologies. And remember, different photo papers have different color and contrast responses.

In order to have more consistent and predictable prints, it is important to calibrate your monitor. This used to be difficult and the required tools were expensive. Neither is true today. Monitor calibration equipment and software are relatively inexpensive and these packages are simple to set up and use. After calibration, the monitor displays the tones and colors in a neutral, predictable environment in which to work on your photos.

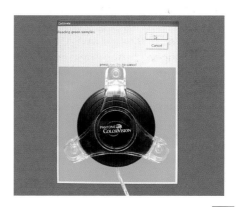

• Monitor calibration is an important first step to ensuring accurate color work with your photos, and more predictable printing.

Color Space

Color is hightly subjective. Two people often look at the same color and see it differently. The computer has to break down all the colors of the world into digital data that can be later reconstructed and displayed to look like those originally captured. To do that, the computer requires parameters, so computer engineers have defined color as a space that can be calculated, interpreted, and controlled.

Color space is not a single entity. There are basic, prevailing parameters like RGB (red, green, blue—the standard computer space) and CMYK (cyan, magenta, yellow, black—common to the commercial printing process). Within that RGB system are even more defined spaces, such as sRGB or Adobe RGB (1998). Each controls color with slight variations in the range of colors and tone. Yet, each is also a standard that is recognized throughout the industry. Once a photo is identified with a specific color space, it is possible (theoretically at least) to display that image on varied, but calibrated, monitors and see the same basic image.

Consistency of colors within the digital realm reaches a higher plateau with consistent color space usage. The standard color space for digital cameras is sRGB and is perfectly capable of giving excellent results in prints. Advanced users of Photoshop will often use a color space called Adobe RGB (1998)—this is a wider color space that allows for more adjustments. It will not automatically give better prints, and if used in an arbitrary manner, can actually result in prints with less color and tone. It does require some work to get the most out of it and is not for everyone.

Testing

At any level of printing, you should always do some sort of testing. You need to know how a printer works and how papers react to the ink. Every craft requires you to try a sample or test, evaluate it, and then make adjustments based on what you have learned.

The simplest form of testing is to make a print and look at it. Is it a good print for you? Never ask if it matches the original unless you are doing work for someone else—that can distract you from your real goal of making a satisfying print that stands on its own. Think of it this way: Who is going to compare your print with the original? All that most people care about is the print in front of them.

The trick is making adjustments to your liking. Be careful though, because you can consume a lot of costly paper, ink, and time if you make a print after every little correction. A quicker and easier way is to prepare a test print. You can make your own test file to print out variations of an image onto one page. This way you can see exactly what different corrections will look like on that particular paper. You can do this with any software, but here are the specific steps when using Photoshop and Photoshop Elements:

Making a Test Print

1 Finish any work needed on your photo, save it, and leave it open.

2 Open the Picture Package part of the program (under File >Automate > Picture Package for Photoshop, or File > Print Layouts > Picture Package for Photoshop Elements).

3 Under Source Images, select Frontmost Document (this is your open image) from the Use drop-down menu.
Your photo will appear in multiples at the lower right.

4 Set the Page Size to 8 x 10 inches and the Resolution to 200 ppi.

5 Choose a number of photos to work with by accessing the Layout drop-down menu—4 or 9 are good choices. Be sure to check the box next to Flatten All Layers, then click OK—the the program will automatically create a new image with multiple copies of your photo on the same page.

6 Leave the upper left photo alone and consider it your "control"—the one image that is identical to what you saw on the monitor.

7 Use your rectangular selection tool to select the first image next to the "control". Make an adjustment to it (such as making it brighter if your prints seem too dark) and record your adjustment.

8 Select the next photo and make another adjustment of the same type, but stronger, and record that, too.

9 Then select another photo and either continue the same type of adjustment or try something else. For example, add 10 points of green.

10 Do this for all the small photos. At first, your adjustments may be random. But after some experience, you'll find you make adjustments in more methodical ways because you'll be better able to read your photos for printing.

11 Print this out and look at all the small images. Which one looks best, or at least heads in the right direction towards best? This helps you know what adjustments are needed for a better print.

Printing Projects

Making a great print can be very satisfying. In addition, all the techniques you learn in producing a good print can be applied in interesting ways to a number of printing projects. This can range from a simple "For Sale" poster to an elaborate brochure. Being able to use photos in many different ways, both for pleasure and business, is a real joy for photographers.

Postcards
Postcards are a wonderful way of utilizing your photos and sharing them with others. Postcards are so quick and easy that you can use them for many things: birthday greetings, birth announcements, thank you notes, business promotions, or keeping in touch. You can buy postcard-printing paper made for this purpose.

Letterhead
A friend of mine in the photo business incorporates a small image in his letterhead and he changes it every time he sends me a letter. This is a very impressive, yet subtle, way of

reminding people about your business. Most word-processing programs can add photos. Many photo and design programs actually include letterhead designs that you can modify with your own work. You should reduce the size of your photo so it is the size used on the page at the needed image printing resolution, such as, 2 x 3 at 300 dpi. When working in programs like Microsoft Word, add your photo into a text frame, don't add the photo directly to the page. By inserting a text frame first, then inserting a photo into it, you can more easily move and position the photo on the page.

Mule's Ear flowers

Grand Tetons National Park
from the camera of Rob Sheppard

Mailing Labels

Mailing and address labels are so easy to do today that I am surprised that I don't see more of them used with photos. You can get labels of almost any size, plus many photo and design software programs include specific templates for the exact label you buy. Not all of the labels use photo-quality paper (though many do), but I'm not sure that's really important. Having a nice photo on a label is so unique that it will stand out no matter what type of label paper is used.

Photo Montage

When you put several photos on a single printed page, you gain some wonderful opportunities to make a very special print. One way of doing this is to create a montage. This technique layers photos on and around each other so that the group of photos becomes one unit. The easiest way to make a successful montage is to plan it around a single strong photo. There are certainly other possibilities, but when you use a single strong photo as the largest image, it becomes a foundation for the montage as well as an anchor for the viewer's eye. Then build the image with smaller photos that interrelate with the big one.

Montages are usually best made by using either a design program or an image-processing program with layers, since either type of software allows you to move the individual elements around by simply clicking and dragging the photo. You will want to be able to move the photo pieces until the montage looks just right.

Printing Multiple Photos on a Page

There are many situations where you want to print more than one picture on a single sheet of paper. You may wish to print a group of 4 x 6-inch photos onto sheets of 8 1/2 x 11-inch pages, or maybe you want a "picture package" that includes several different sizes on a page. Either way, it can be more efficient and cost effective to maximize the use of the paper.

You have a number of options for doing this. Often, the software that comes with your printer will offer this capability. Adobe Photoshop and Photoshop Elements include a Picture Package option in the File menu (see page 91). You can select a whole series of multiple-picture layouts that can be printed with duplicates of the same photo or different images. In addition, there are some stand-alone programs that make multi-picture printing very efficient and don't require you to open an image-processing program. These include ArcSoft Photo Printer and ACDSystems FotoSlate.

A photo-led feature on the green heart of the Baltic States, its nature and culture

Agent:
Sue Fogden
susan.fogden@virgin.net
+44 1736 380311

- Photo flyers are easy to do with an ink jet printer as long as you use the appropriate paper.

Photo Flyer

A flyer is like a montage because it has multiple photos on a page, but a flyer is something that has a strong message, often business related. The photos and text must be carefully chosen so that they work to support the overall message. Flyers are often weakened by poor use of text and by the placement of too many small photos. You may want to experiment with some of the design templates offered in many of the low-end image-processing programs and design software. Check out the design books by Robin Williams for some excellent ideas about creating a flyer and other designed projects.

Newsletters

Family newsletters with photos have become very popular in recent years, due in part to the computer and ink jet printer. They are now used more often, not just at Christmas. In addition to families, many businesses have found newsletters to be a great way to keep in touch with clients and customers. Because newsletters are fairly easy to produce, they often look like they have been thrown together with little thought to the design and use of text and photos. Many design and image-processing programs include newsletter templates that can be excellent starting points (and can be worth the price of the software package). Broderbund even has a PrintShop program just on Newsletters and Brochures.

Use a few photos boldly and don't try to cram too many images on a page. If they fight each other for space, there are too many photos. Look at the front page of a newspaper. Photos are chosen carefully for how they support the stories and attract reader attention. You do want people to read your carefully prepared newsletter. One way to do that is to make it compelling and inviting through the use of selected, but intriguing or engaging, photos. Be bold! Feature your photos!

Posters

With the larger printers, both desktop and graphics ink jets, you may make some wonderful posters that can be used for everything from a dorm room to church events to business promotions. This can be a great way to utilize your photography as well as publicize the organizations you support.

• Digital photos and the computer offer you many possibilities for your pictures, such as a brochure.

Greeting Cards

You can get special card papers (and envelopes) that are prescored for borderless cards and for easier folding. They usually include instructions on how to make a card that has text on the inside as well as photos on the outside. Sizing can be a little tricky, so make prints on inexpensive paper first, and fold them up to see that everything fits properly. Then hold them up against the good paper to see if everything is printing the way you want. Many inexpensive image-processing programs include templates for making cards. If you do a lot of cards, they can be well worth their low cost, even if you do higher-end imaging work in Photoshop.

Brochures

A brochure can be an excellent way to use your photos in a community organization or a business. The key is planning. I find it very helpful to take a sheet of paper, fold it into the shape of the brochure, and doodle notes and pictures on it. Or, find a commercial brochure you like and use it as inspiration. A brochure always has a cover. You need to pay special attention to it, using bold but limited type and a strong photo to capture your viewer's interest. Give them a reason to pick up the brochure and open it. Then you need to look at each piece of the brochure as it opens. Be careful that you don't cram too much text or too many photos into it. That can make it uninviting, causing your reader to stop reading and put the brochure down. Look for brochure templates in many design programs.

Index